A *terra magica* BOOK

HANNS REICH

Laughing Camera II

HILL and WANG · NEW YORK

LAUGHING CAMERA II

Photo Credits

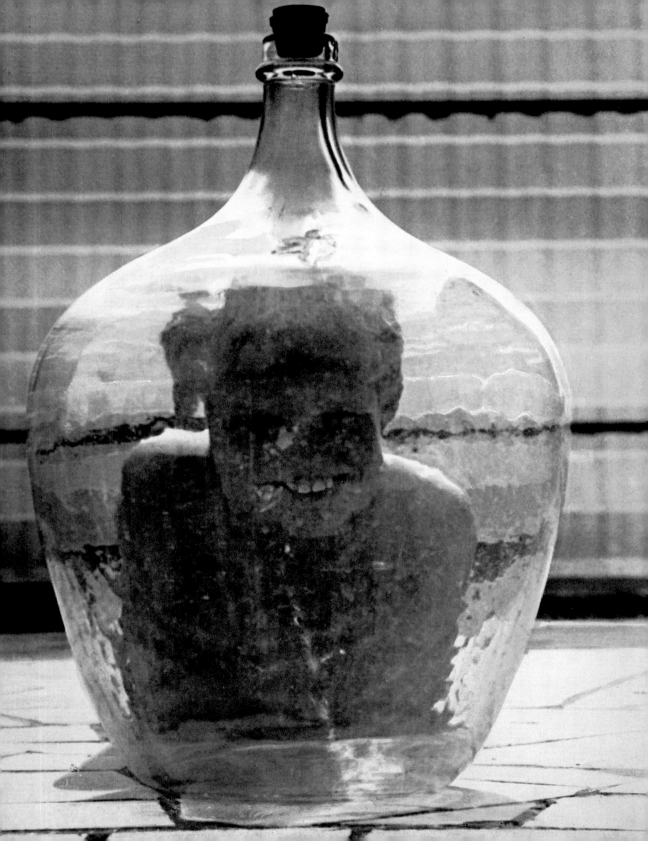

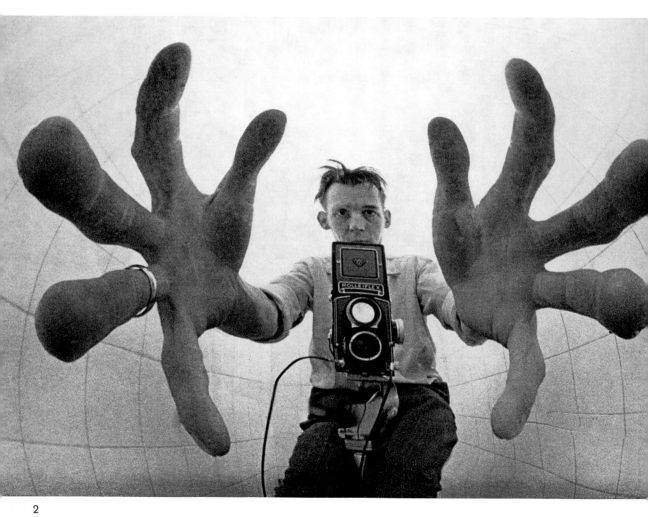

2

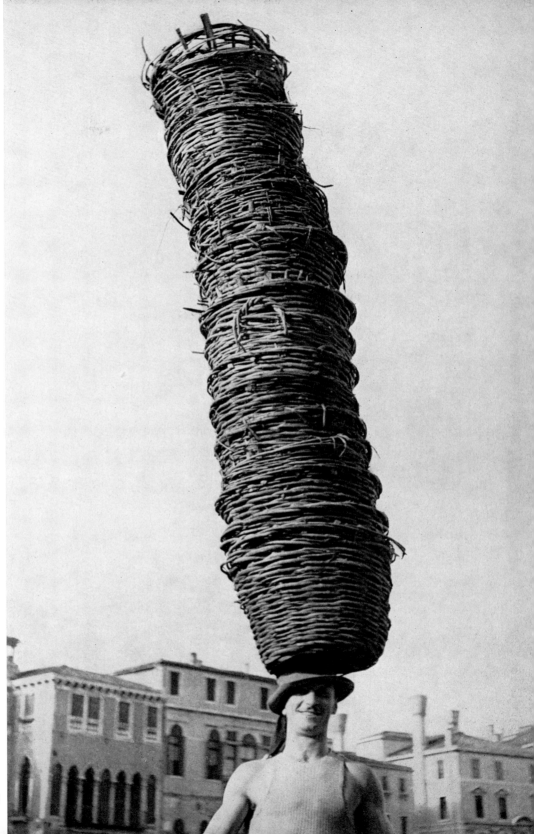

3

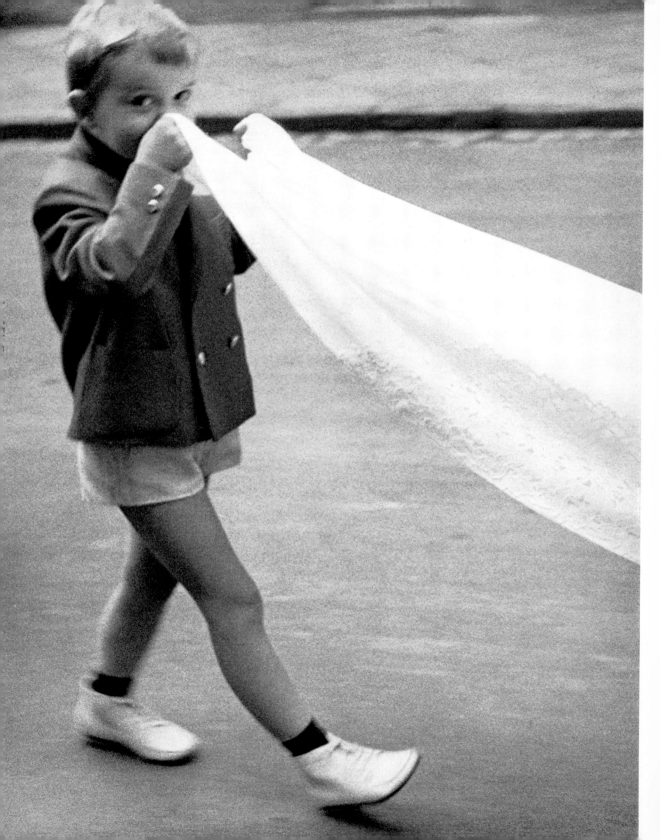

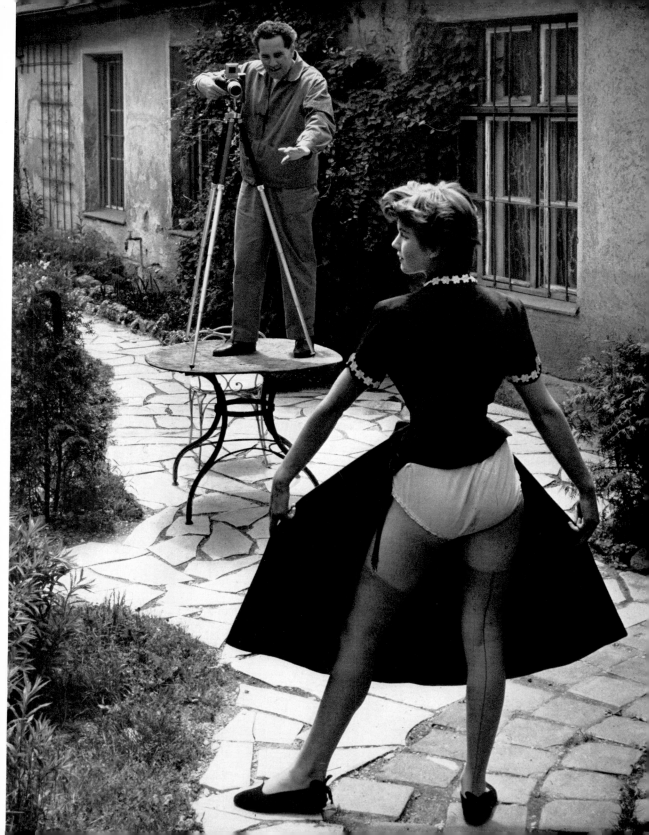

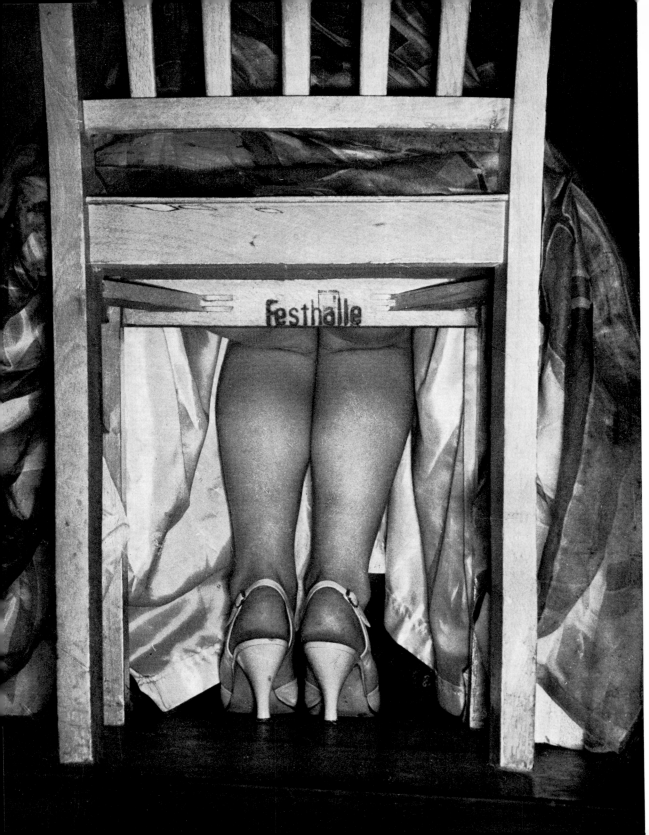

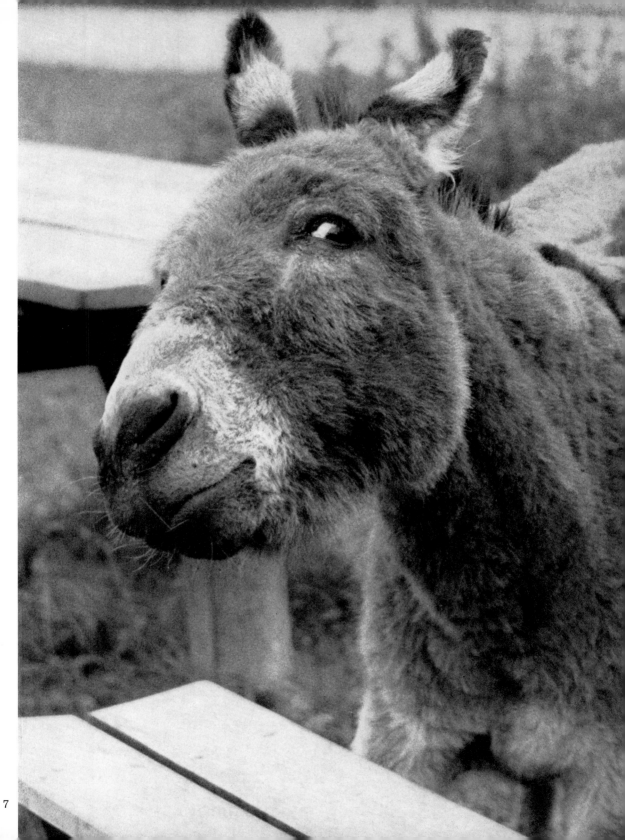

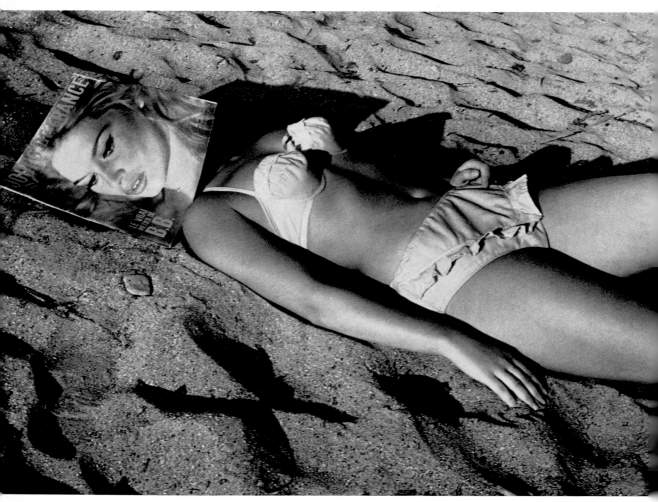

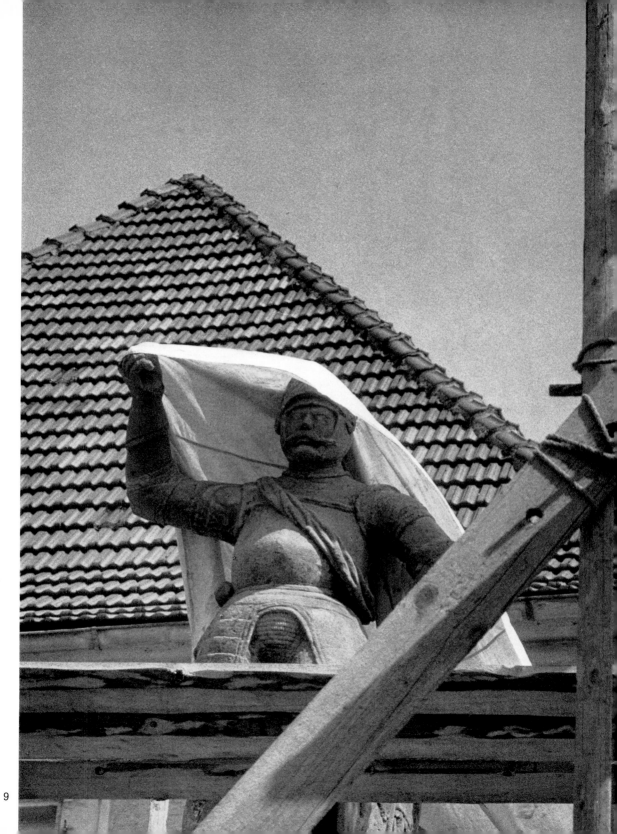

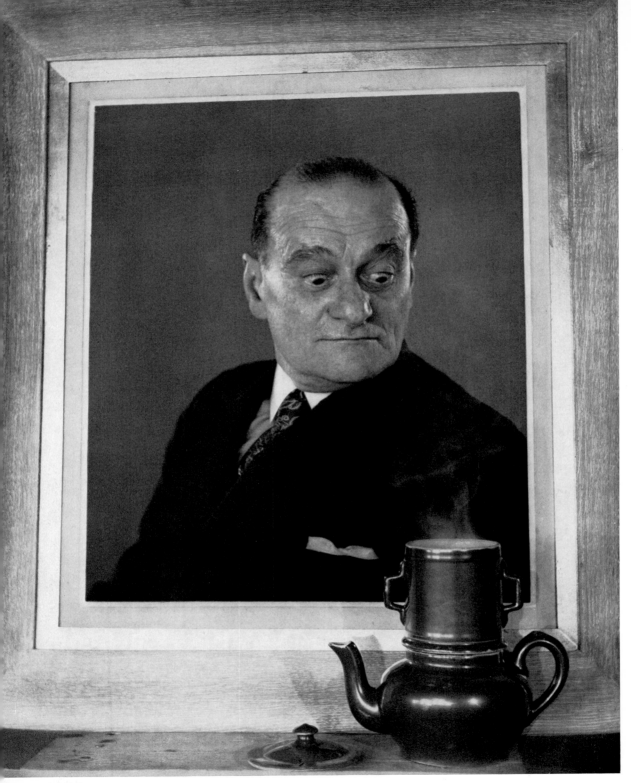

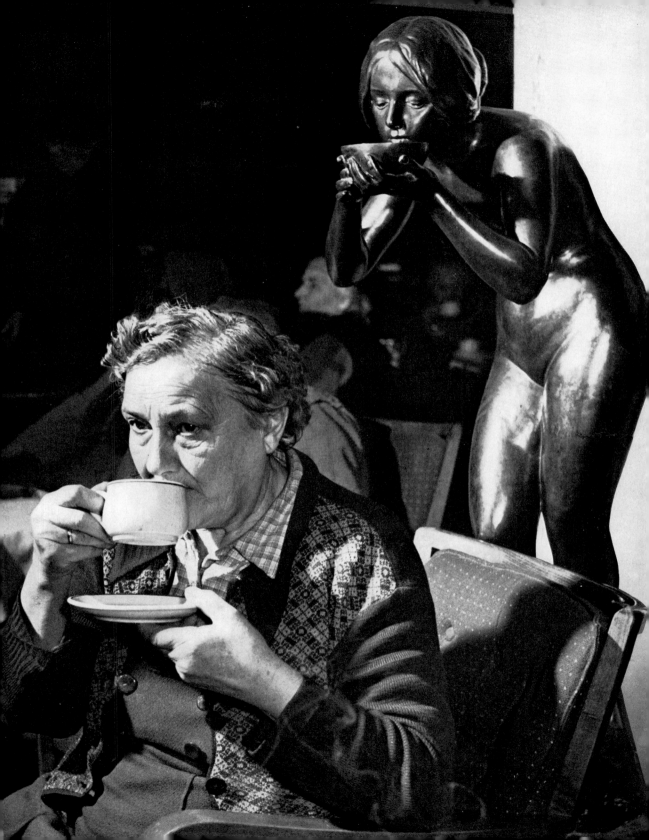

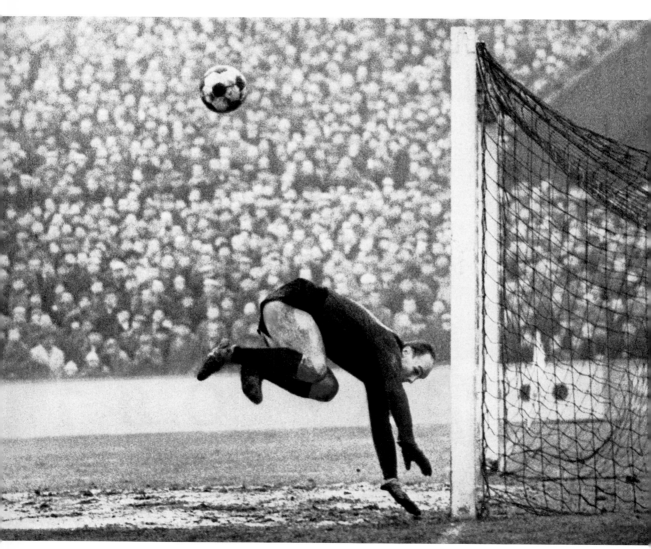

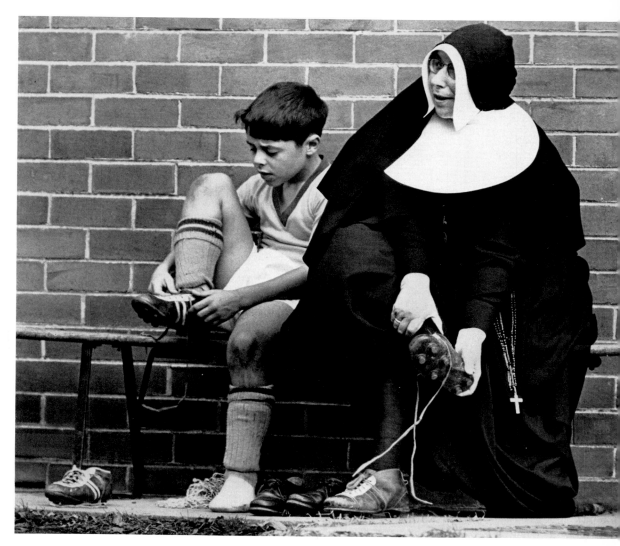

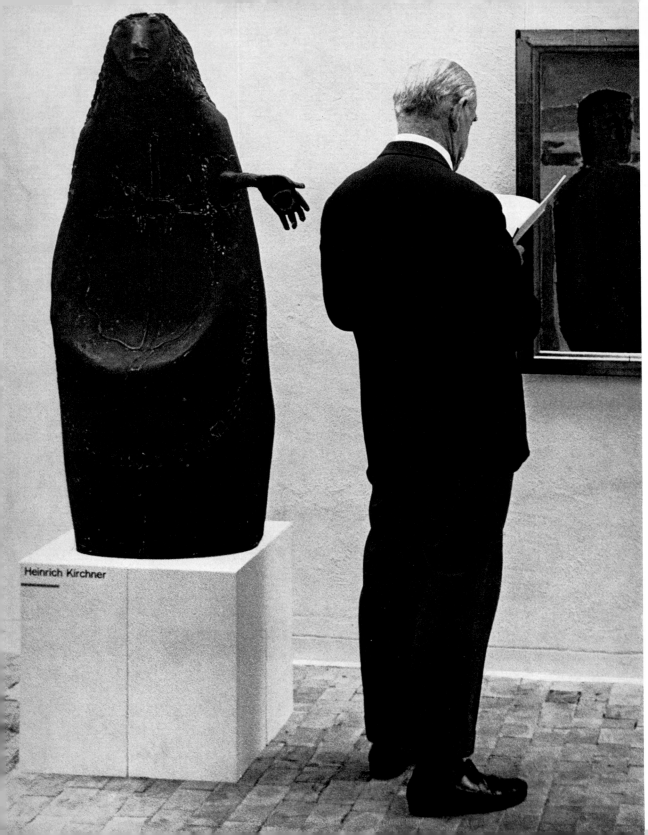

Heinrich Kirchner

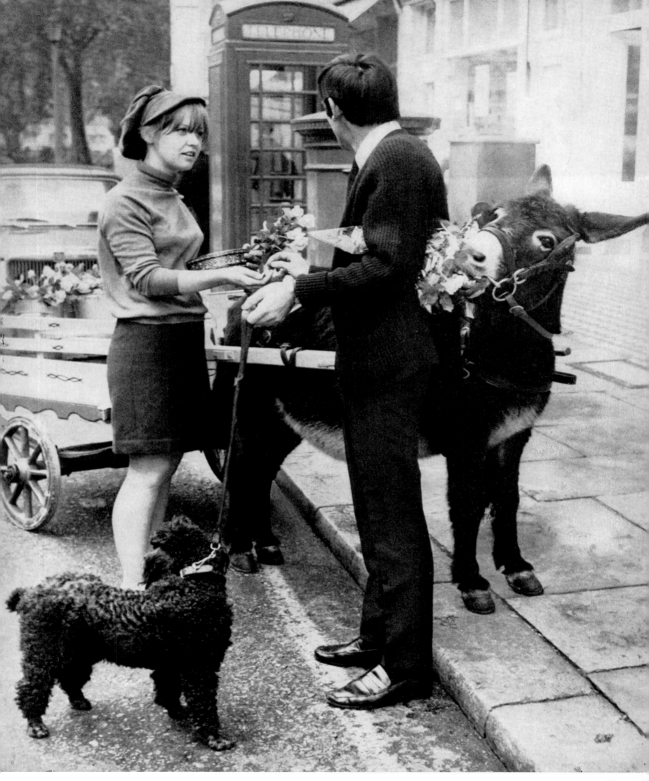

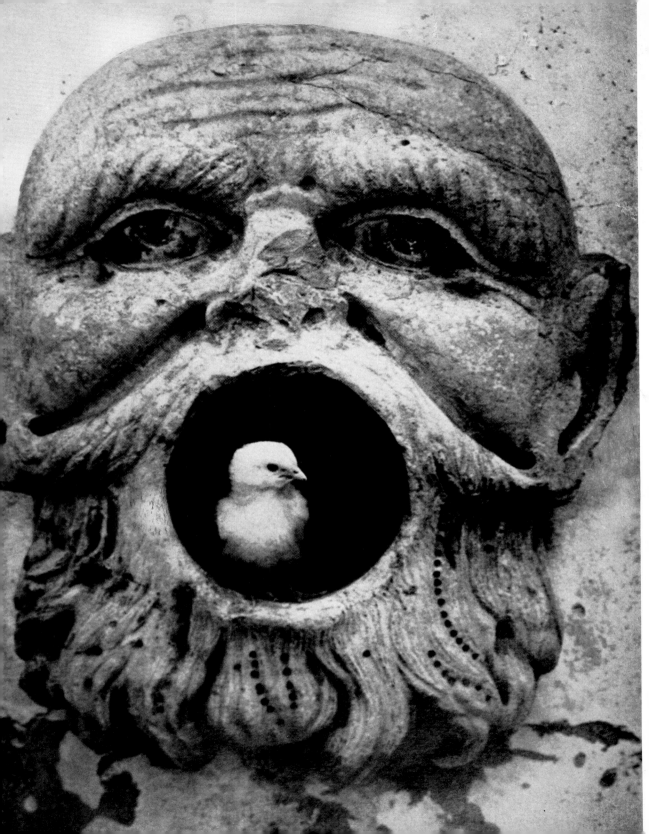

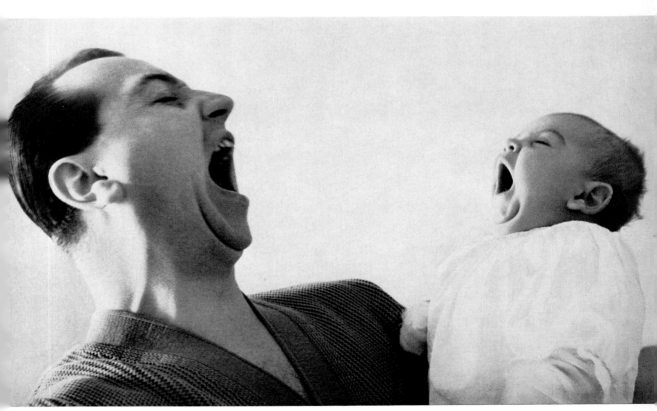

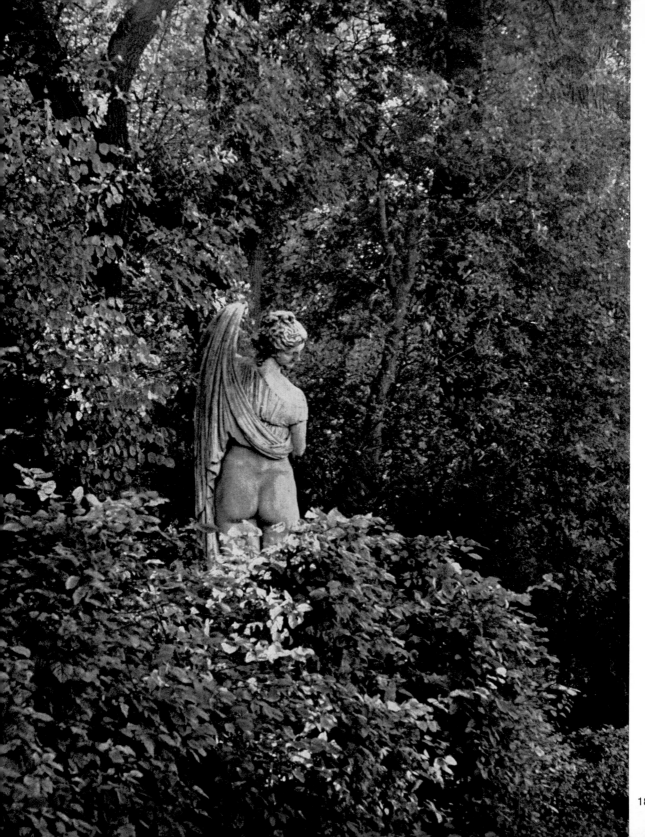

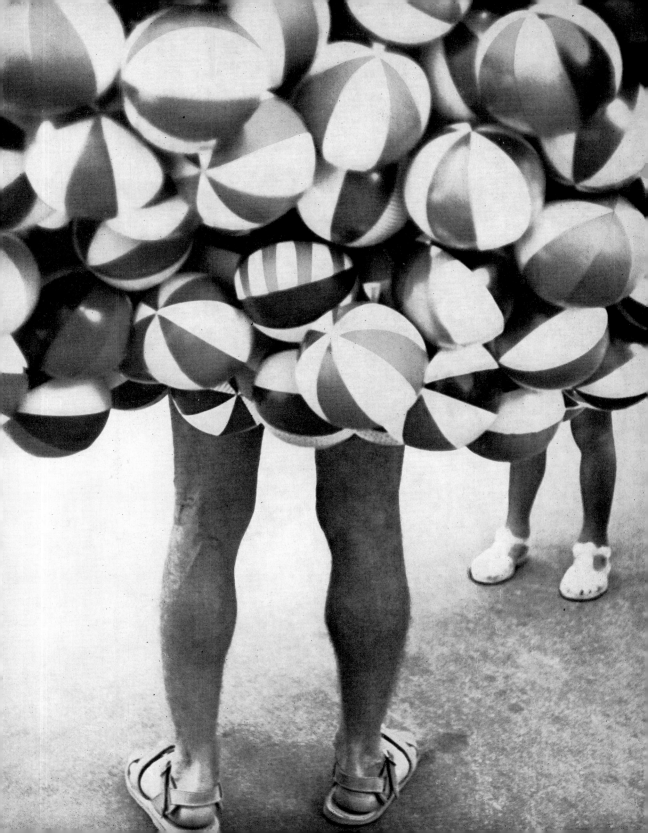

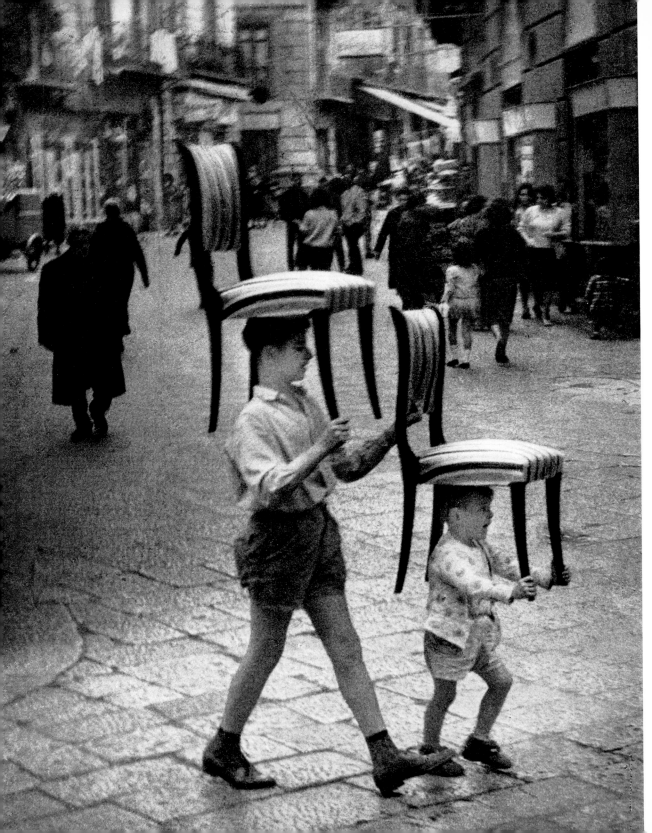

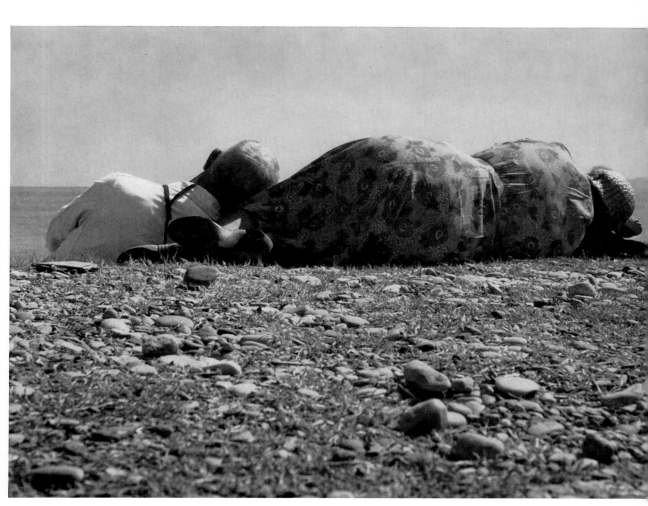

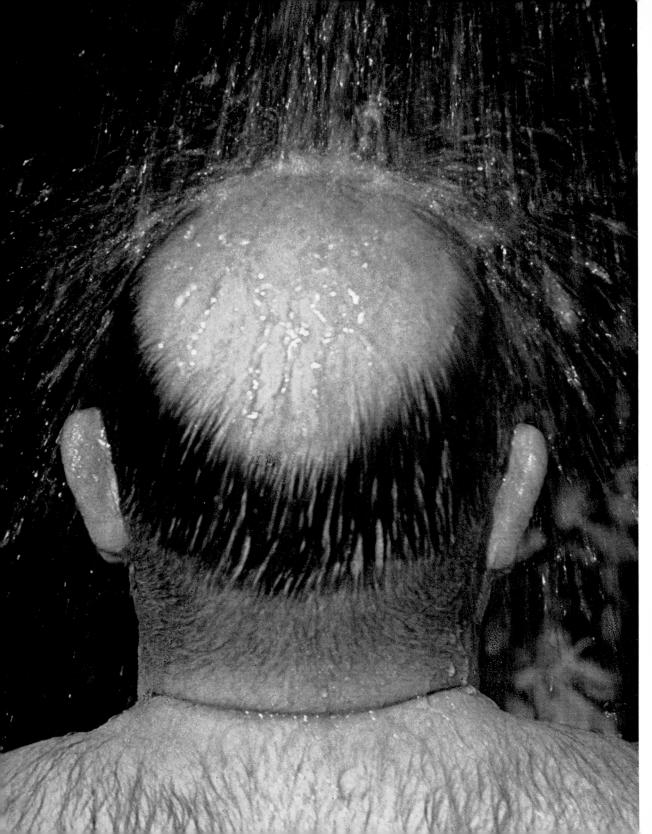

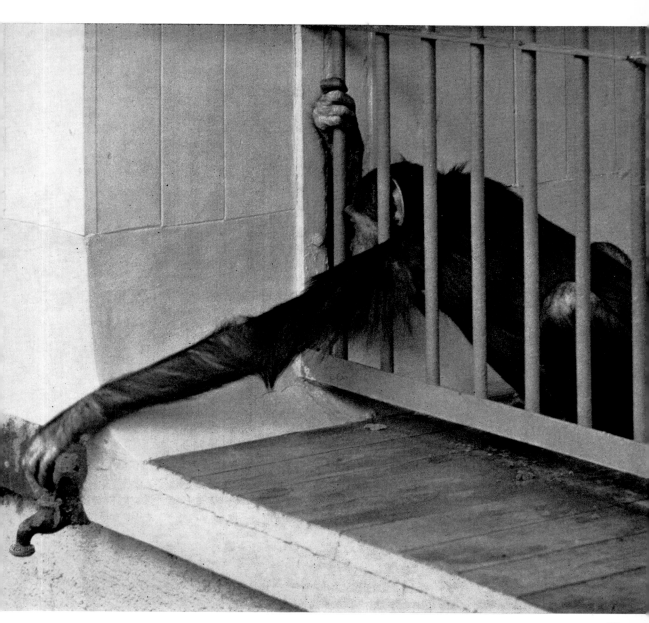

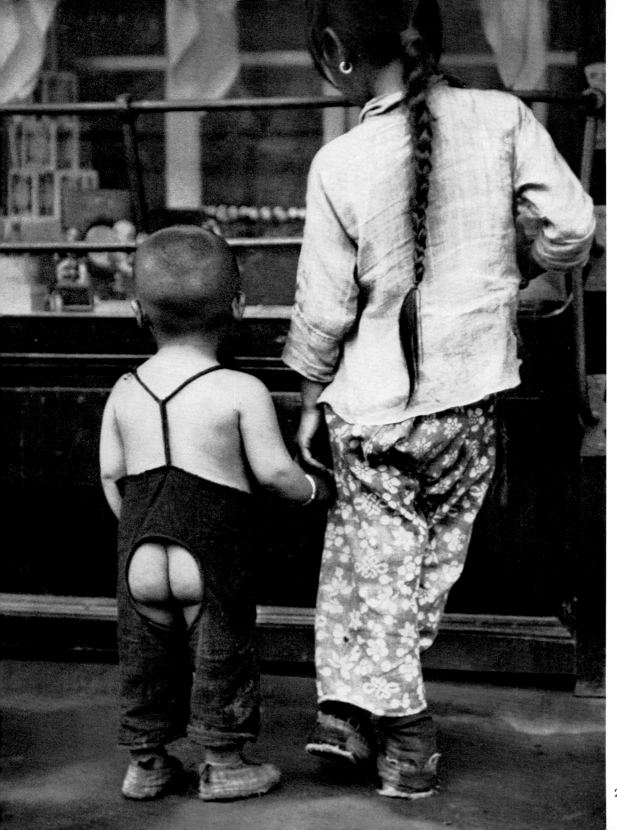

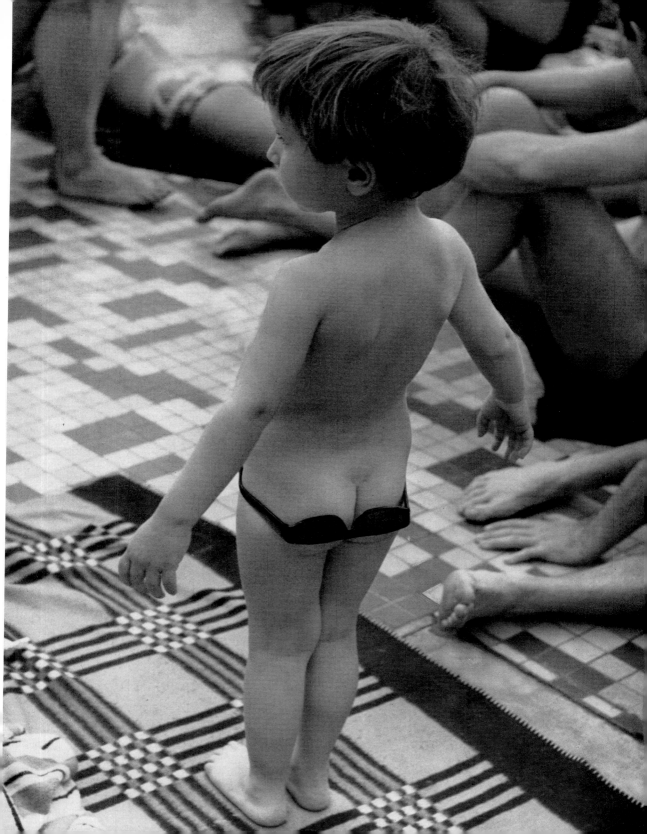

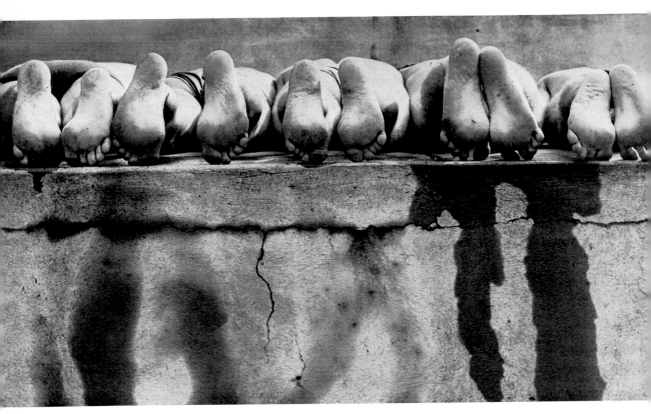

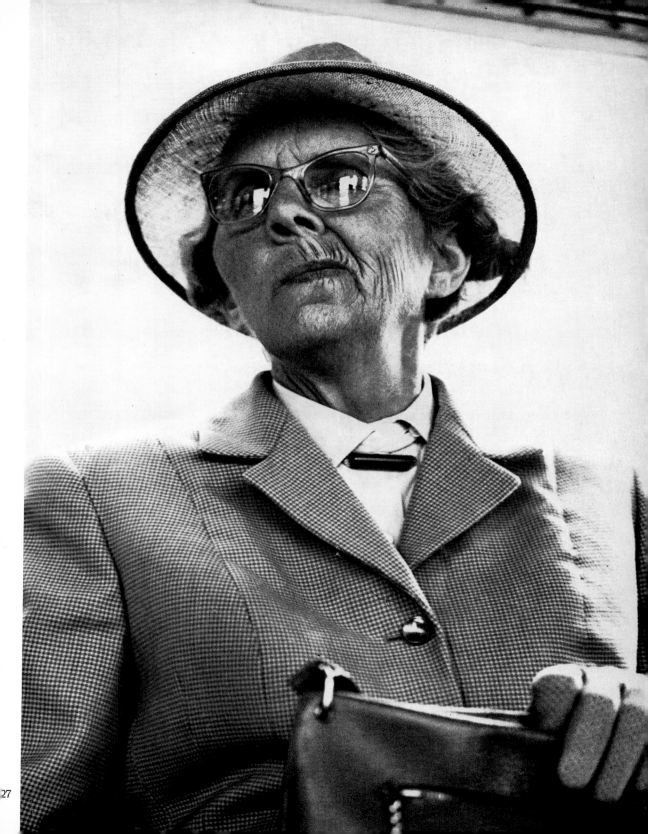

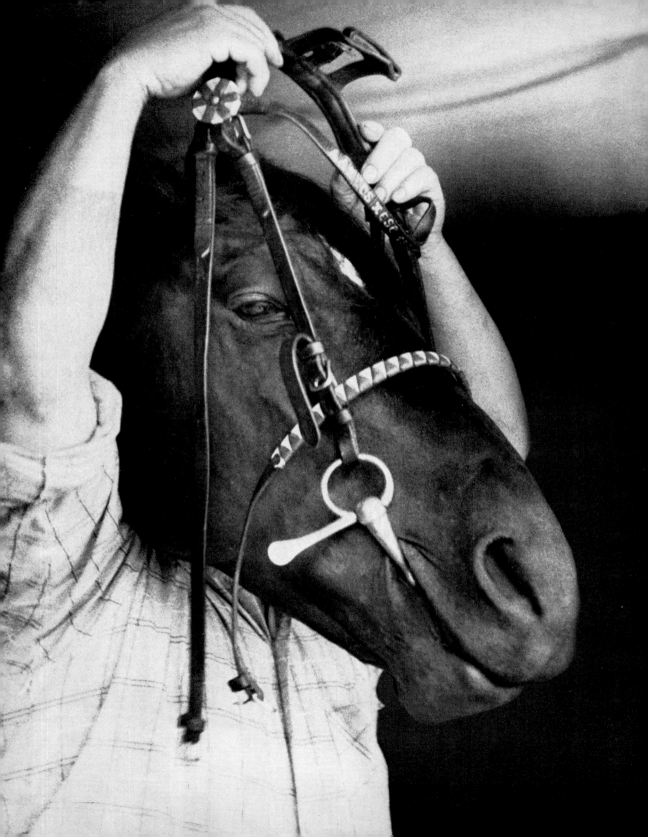

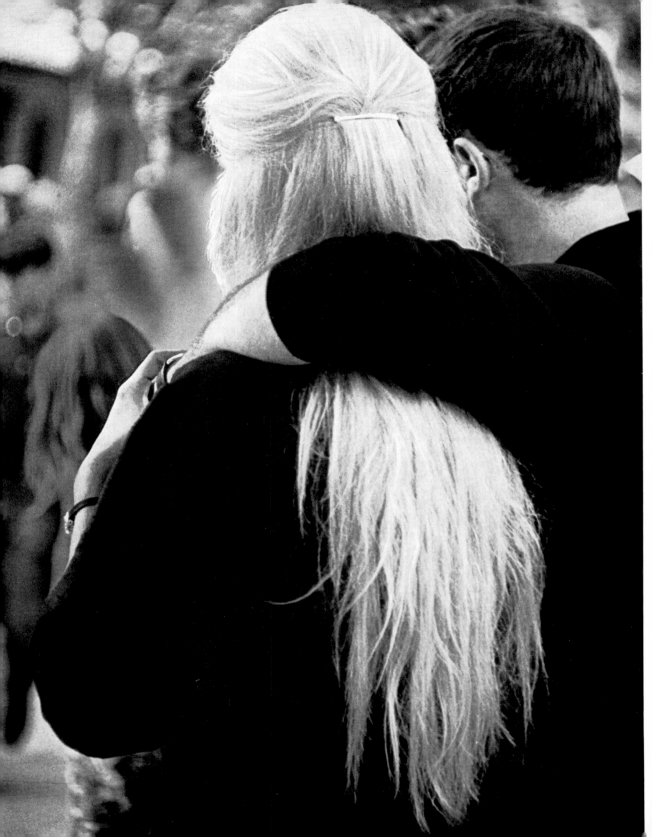

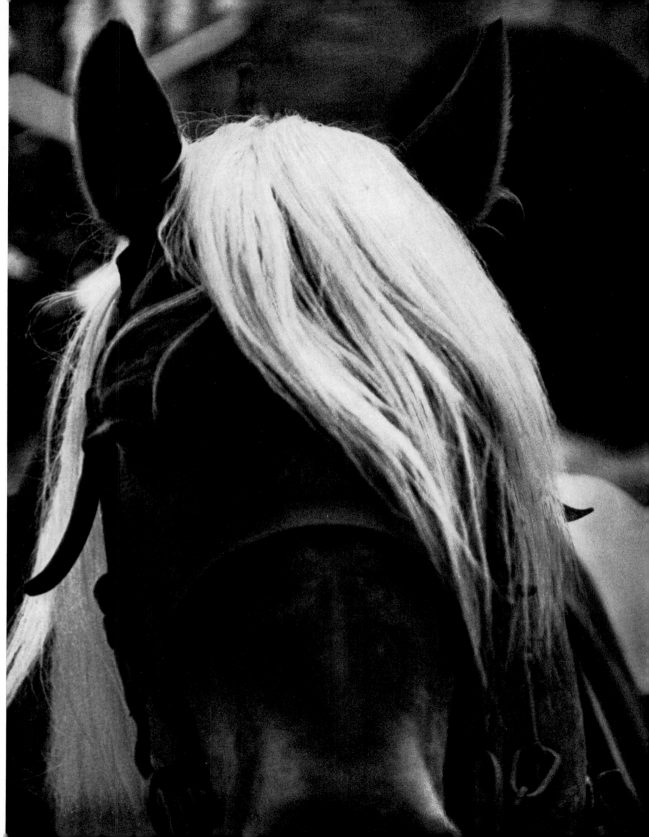

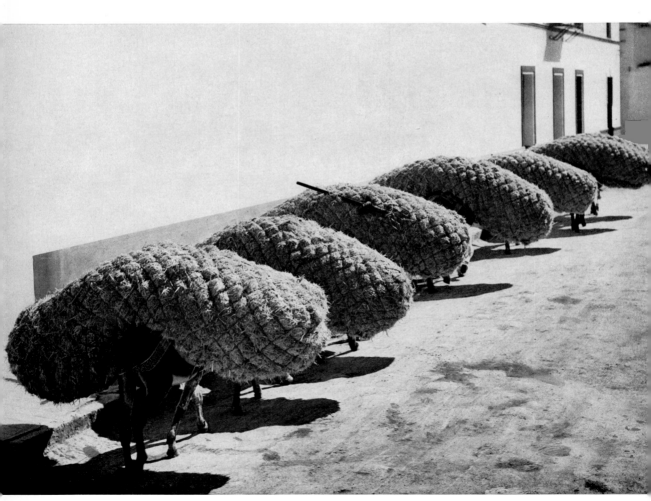

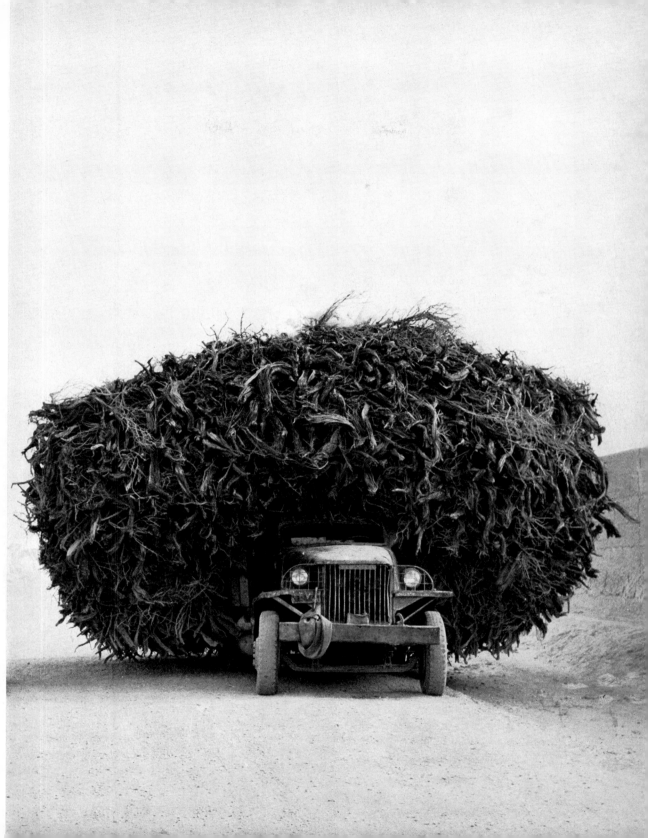

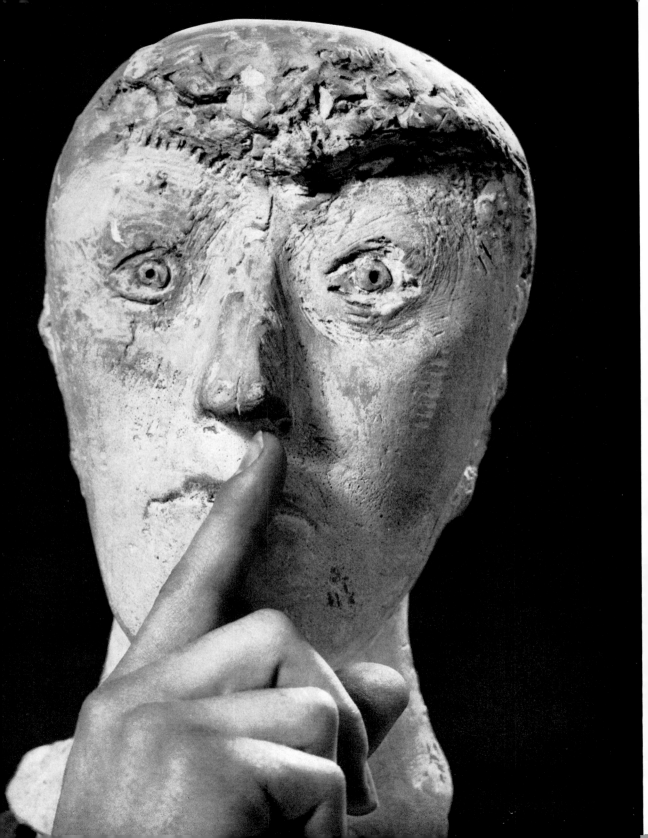

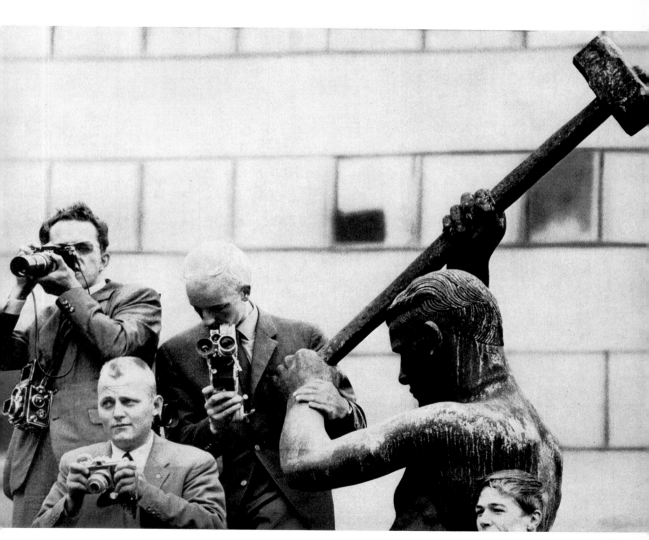

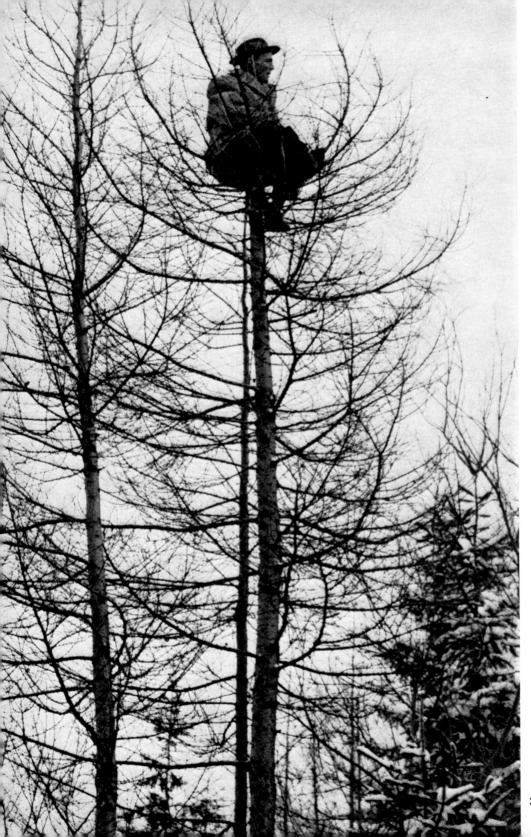

36

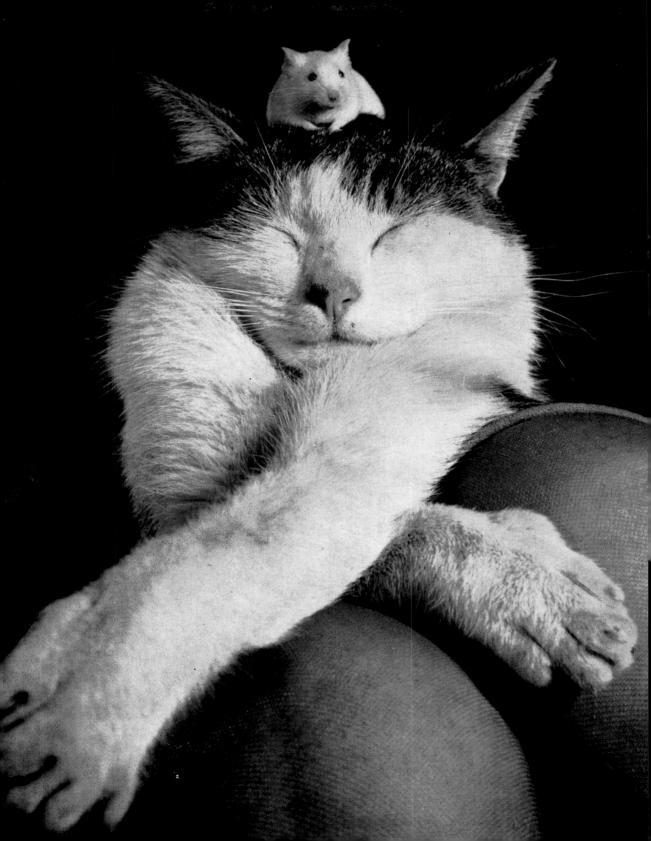

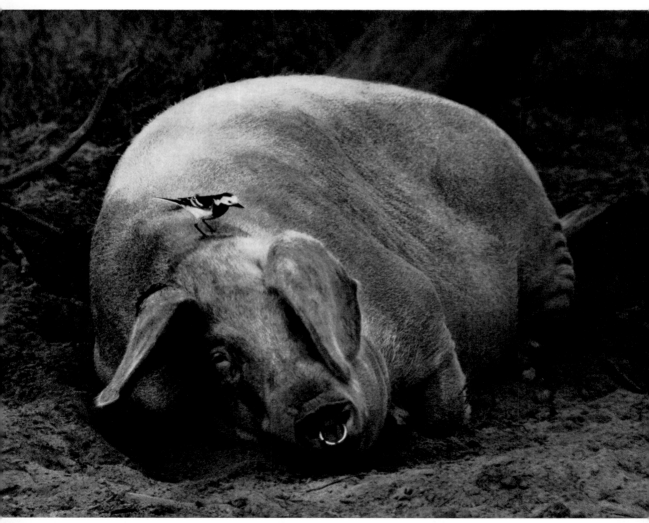

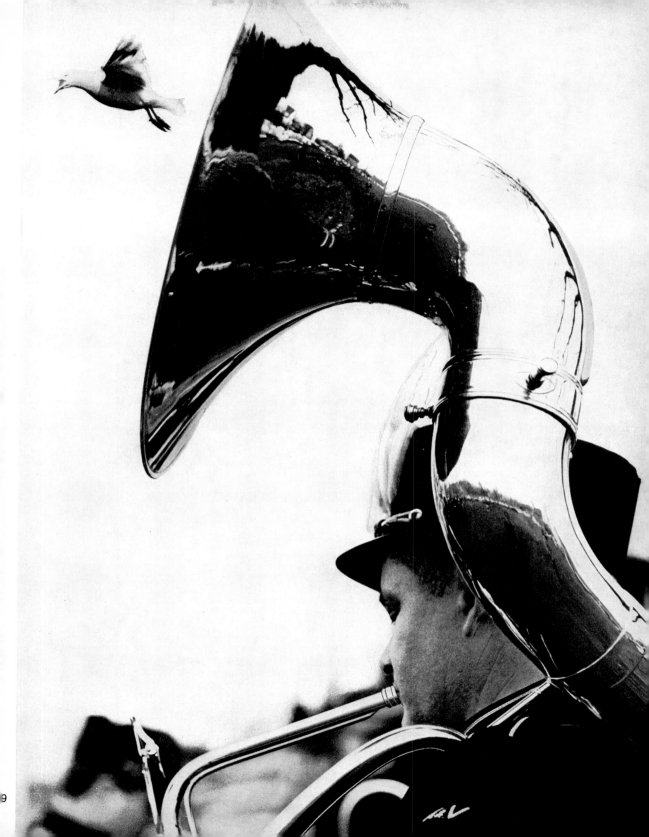

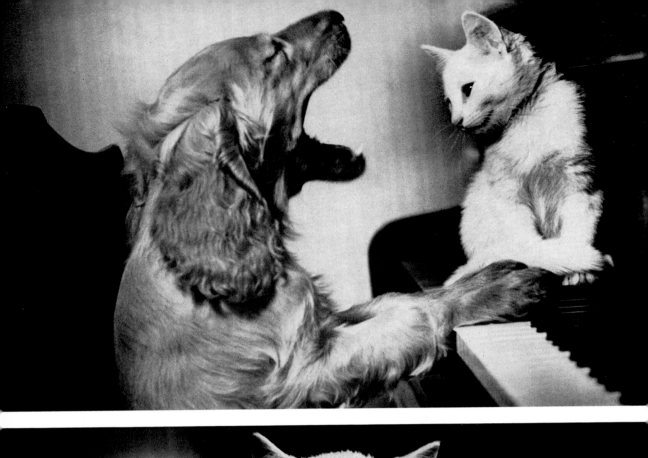

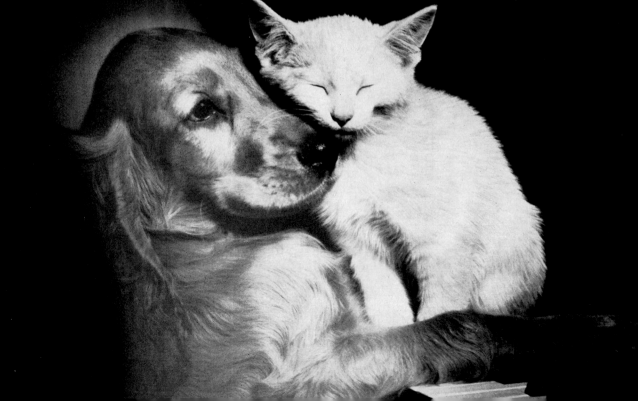

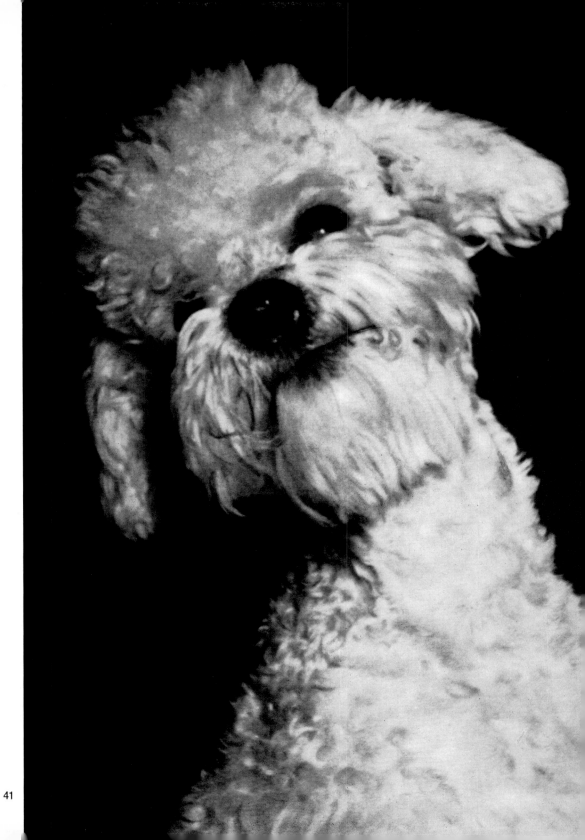

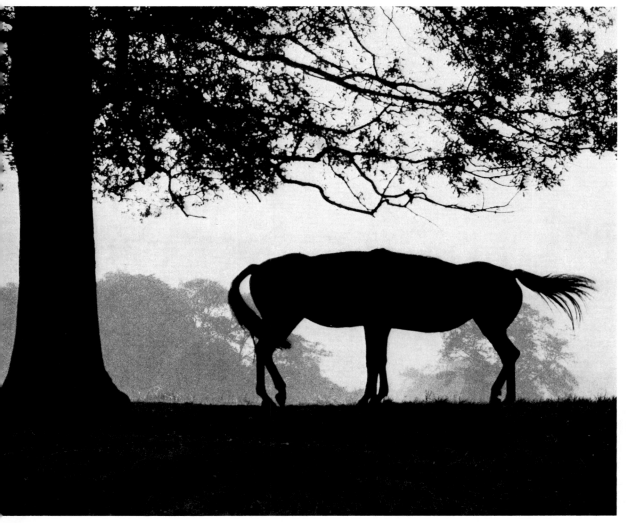

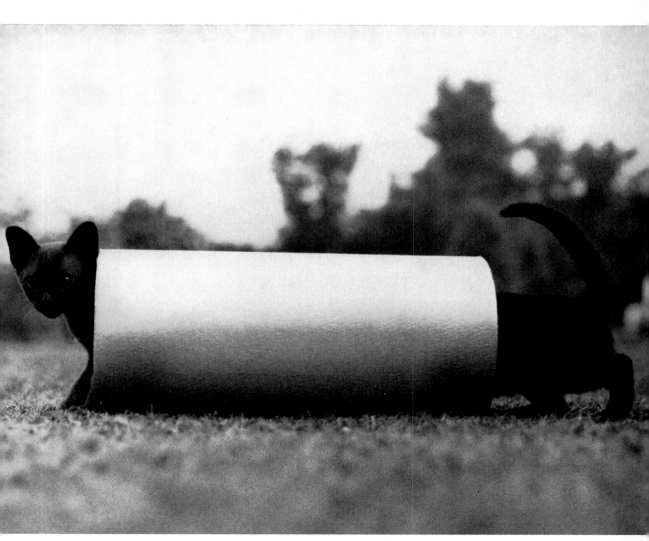

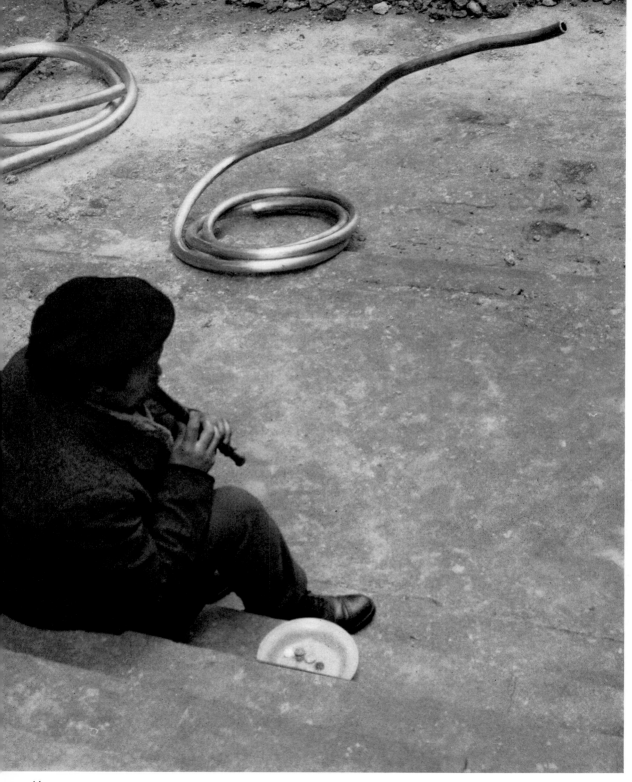

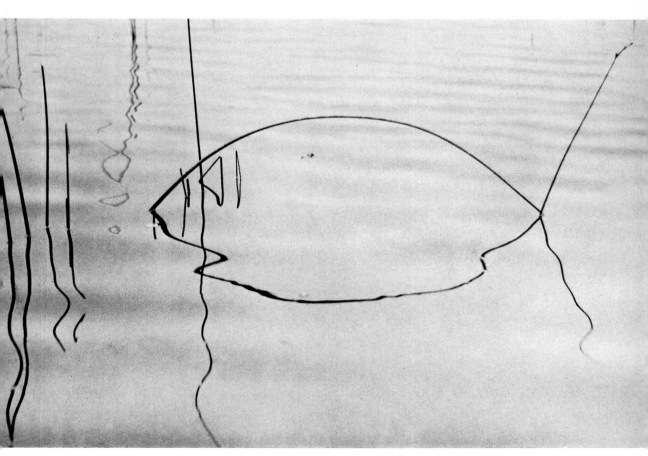

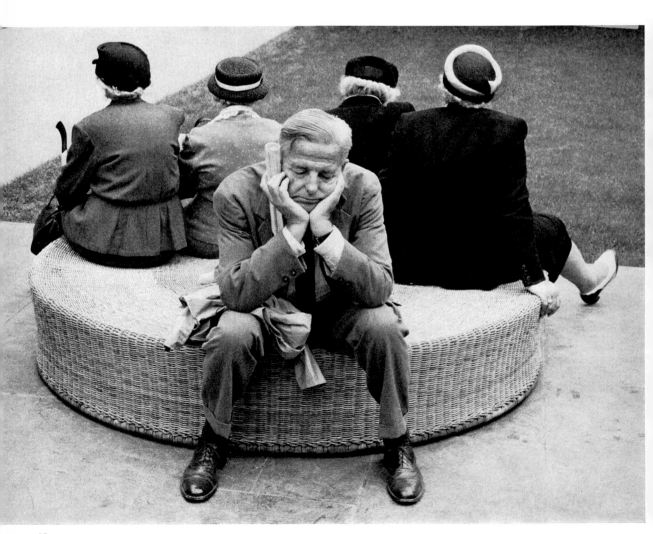

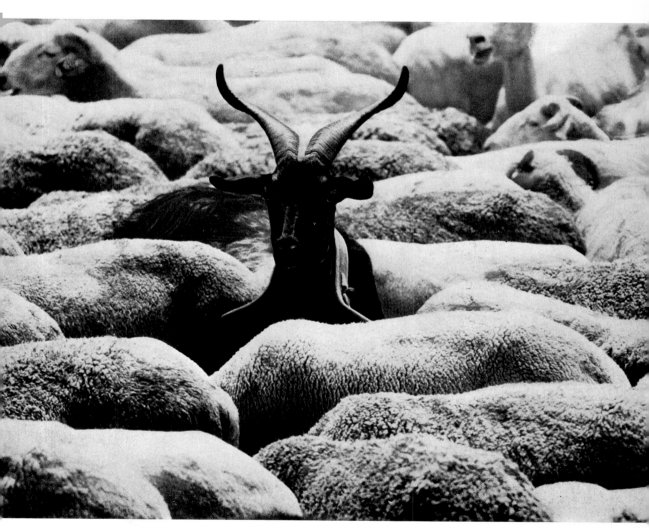

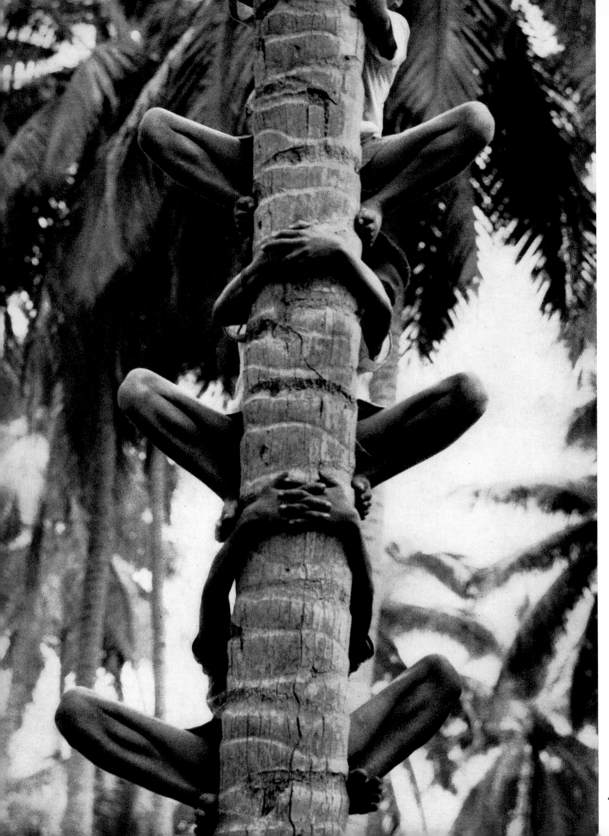

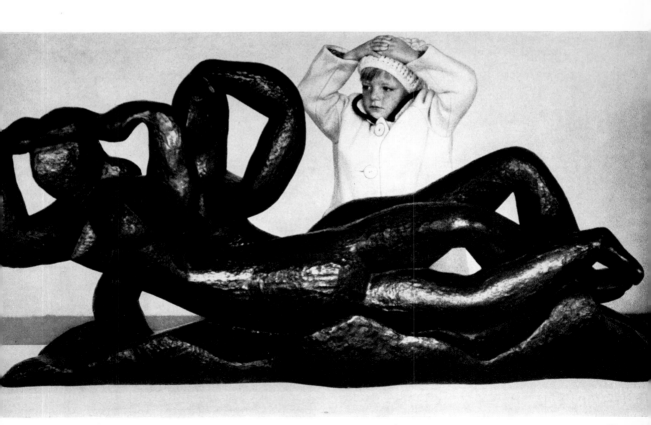

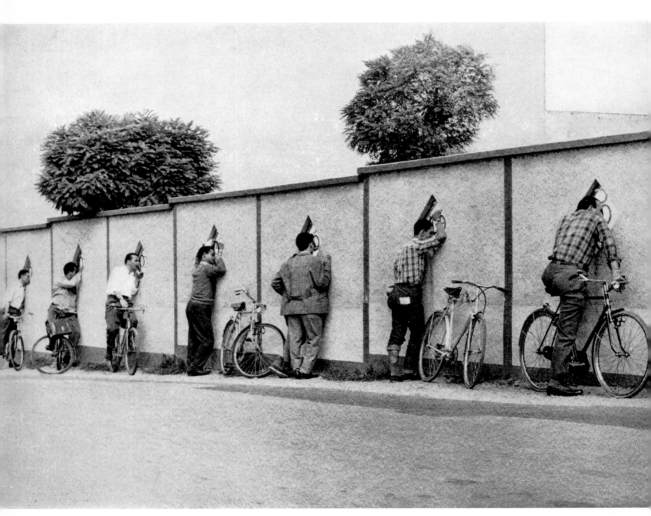

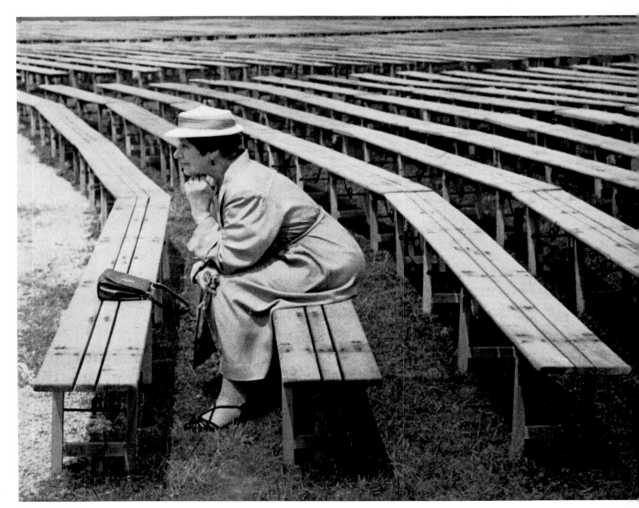

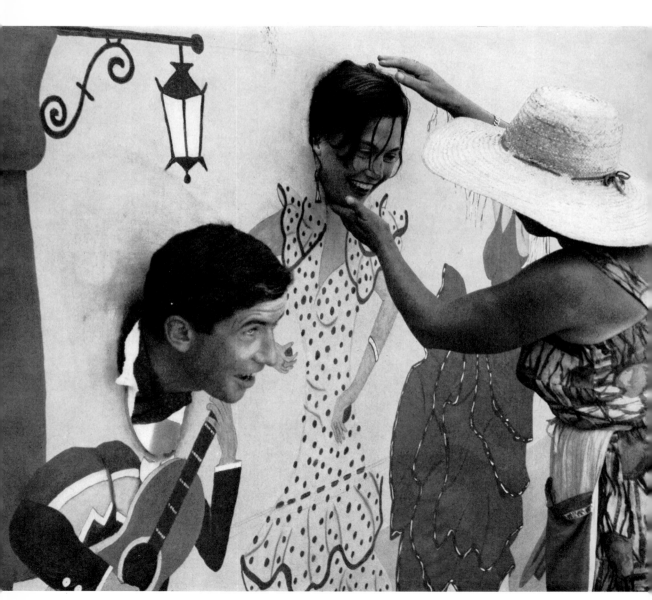

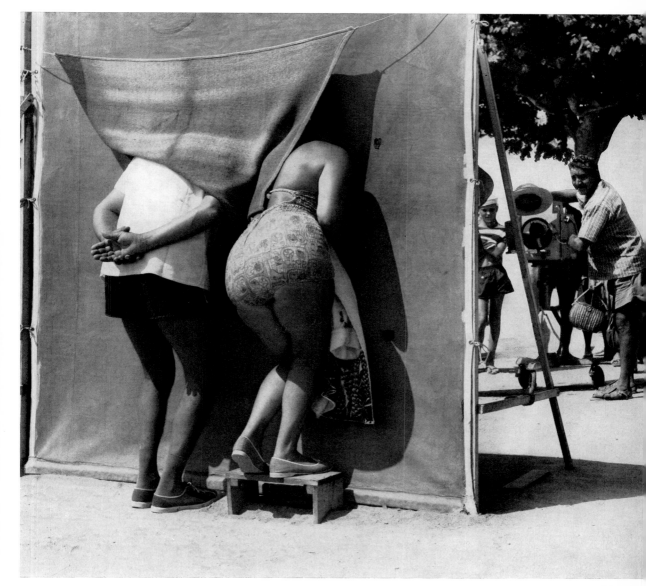

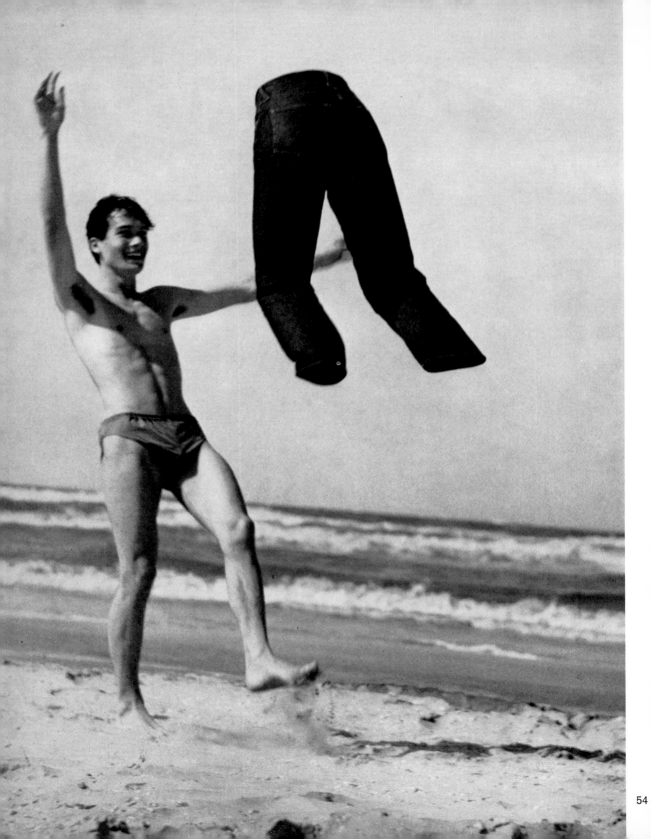

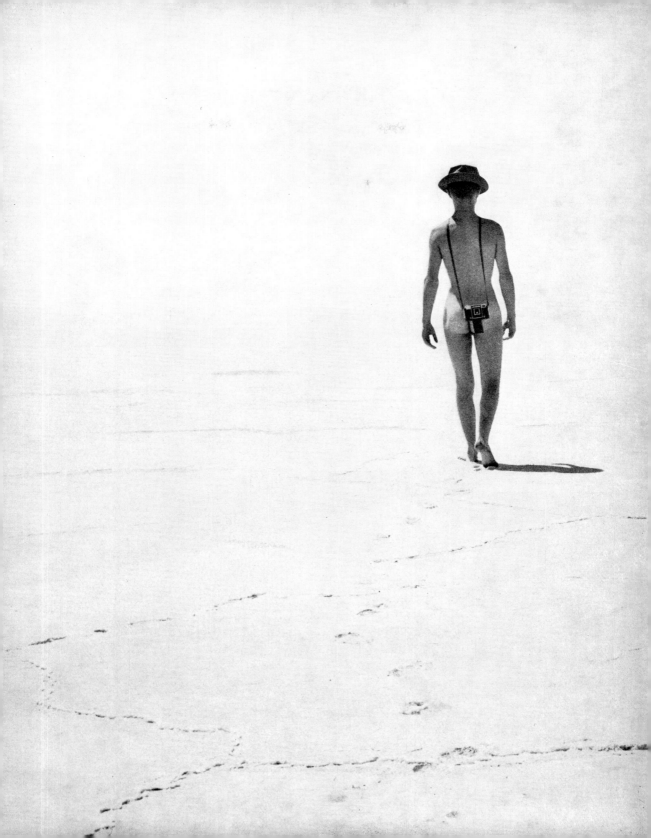

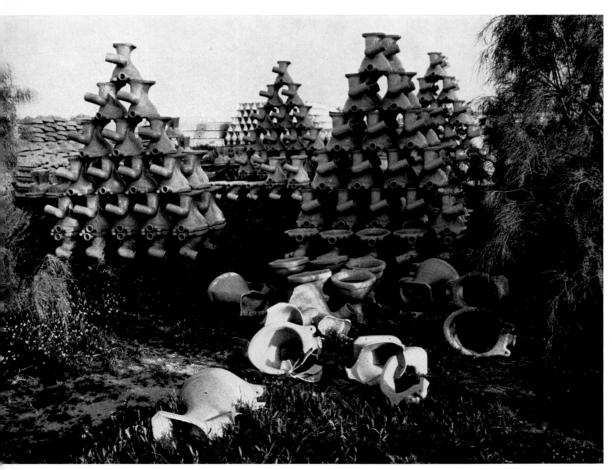

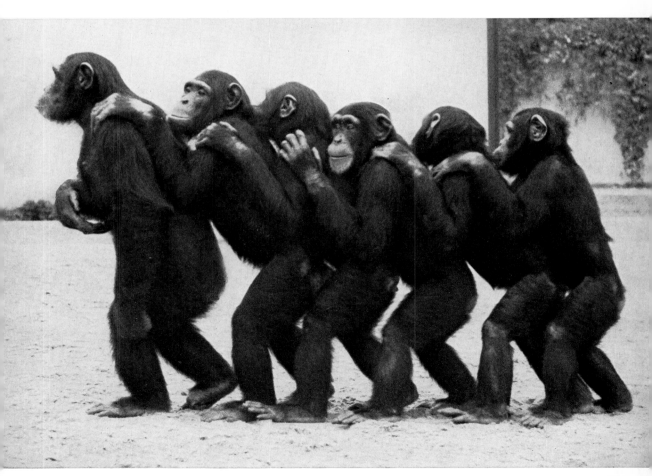

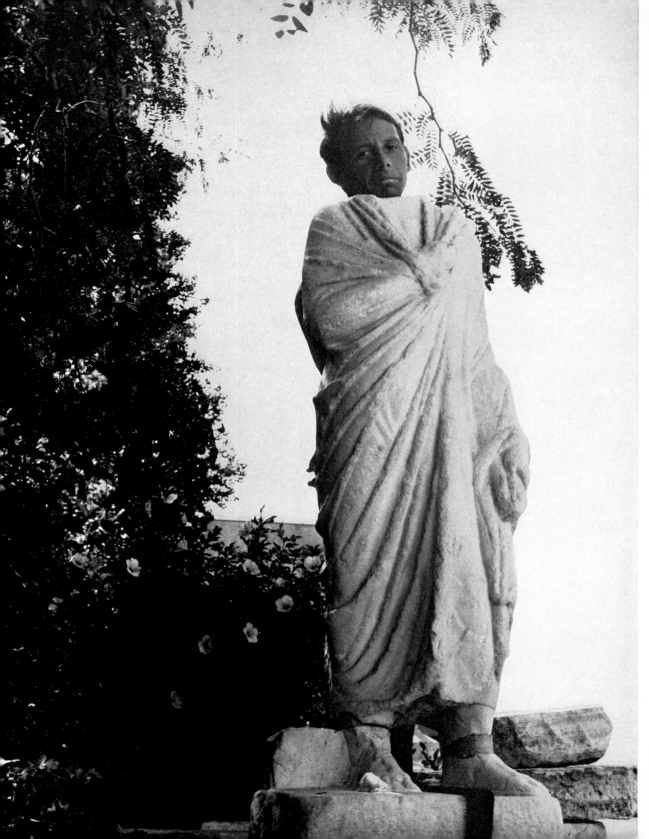

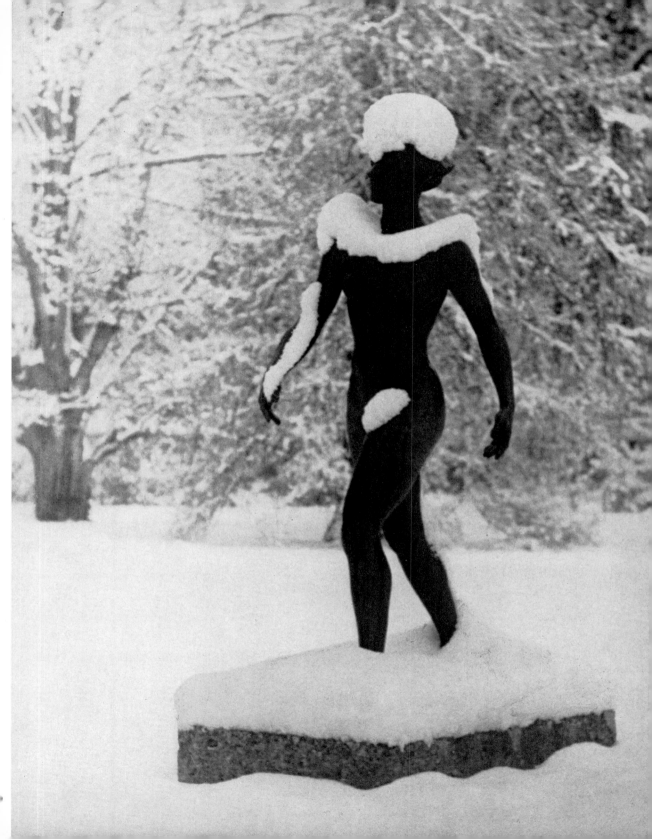

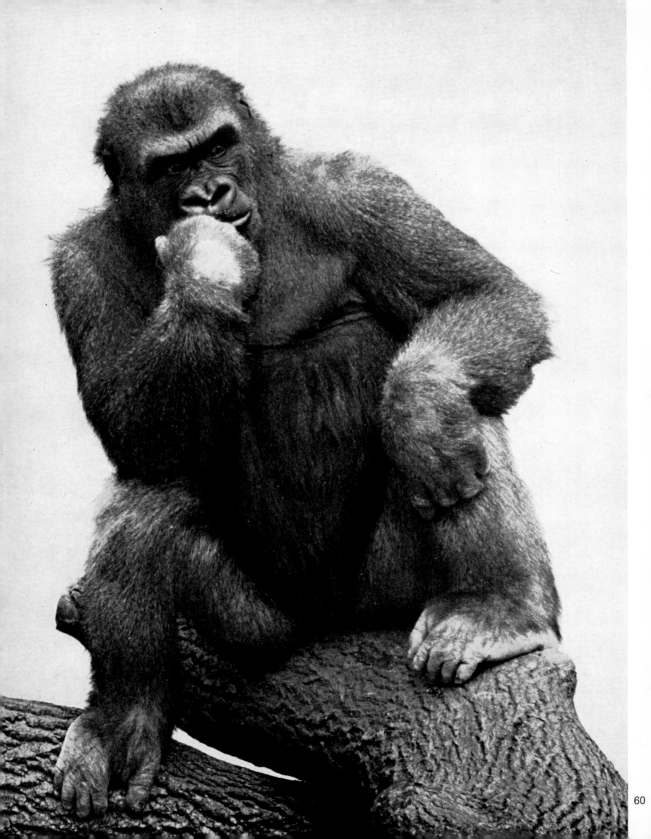

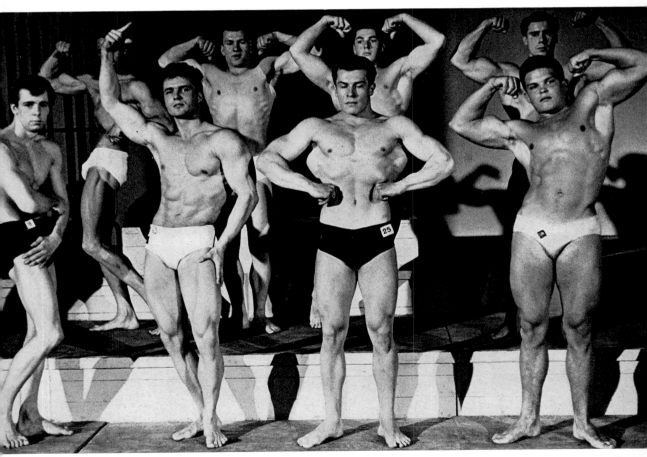

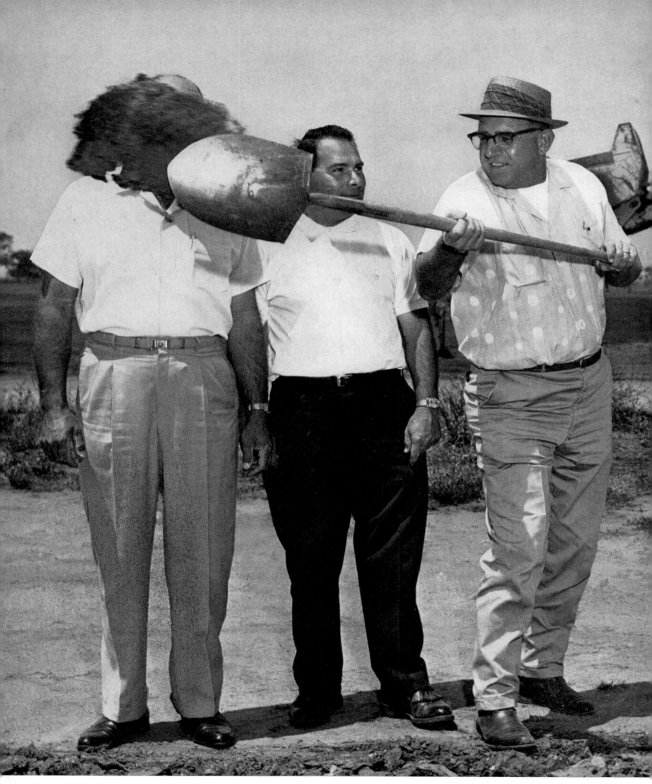

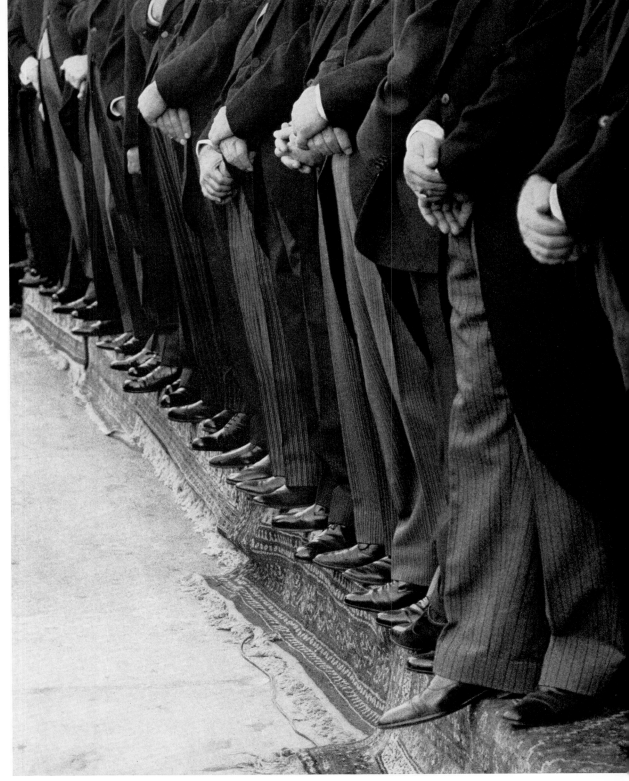

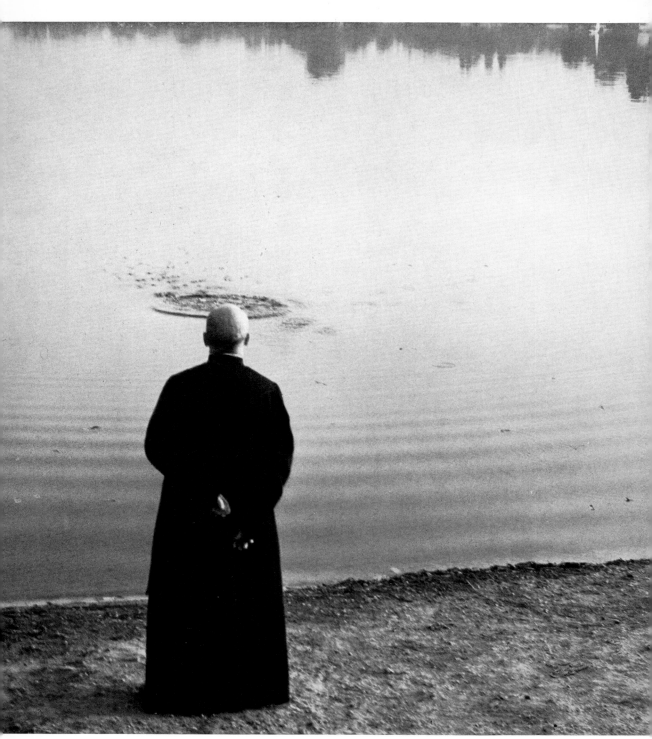

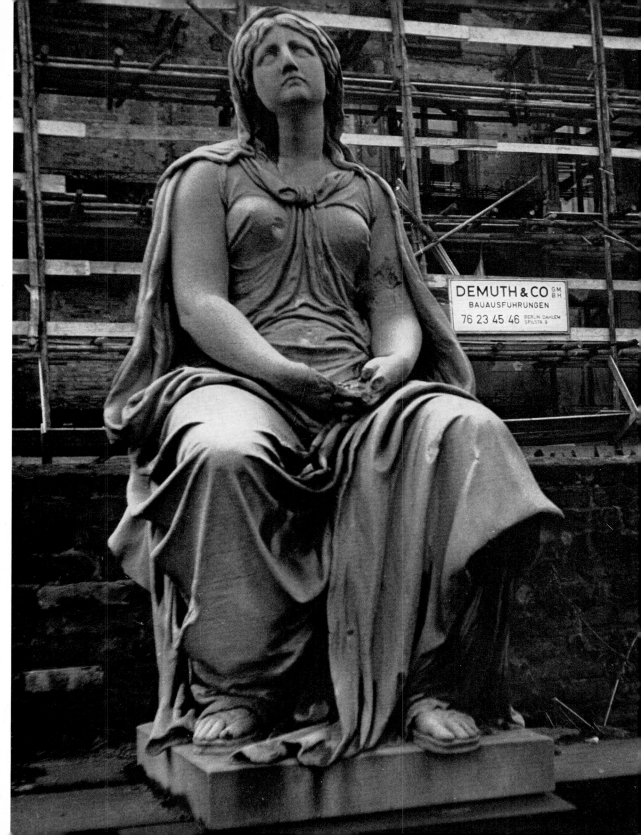

DEMUTH & CO GMBH
BAUAUSFÜHRUNGEN
76 23 45/46 BERLIN-DAHLEM
SPILSTR 8

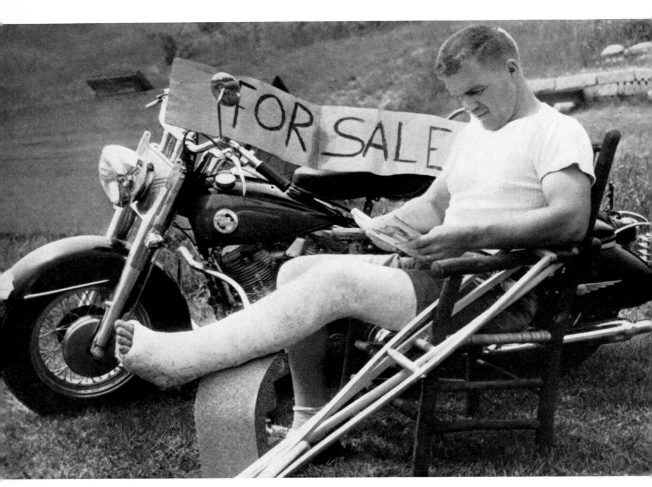

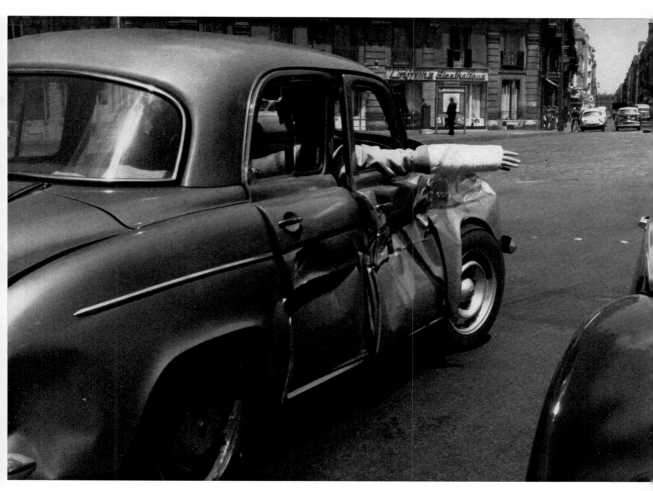

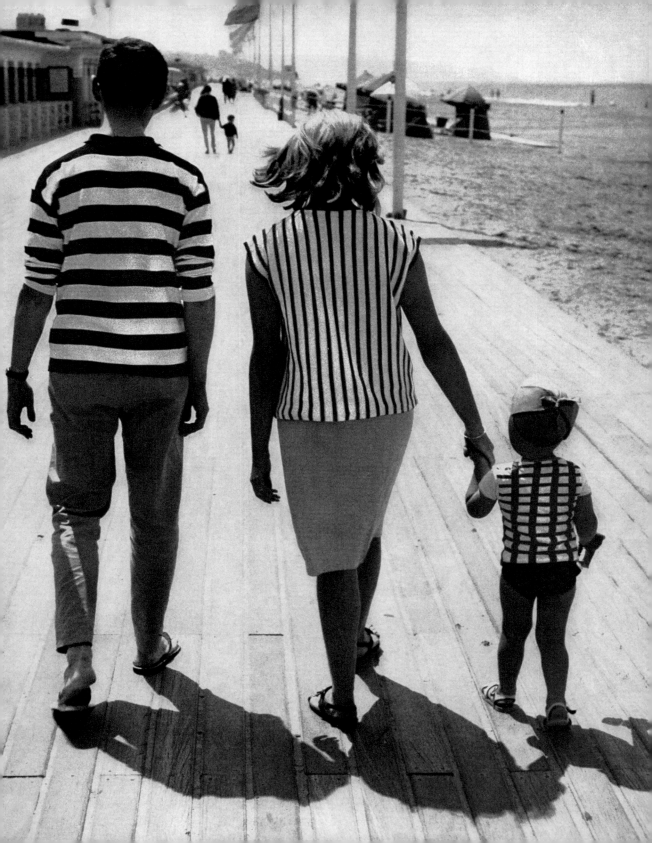

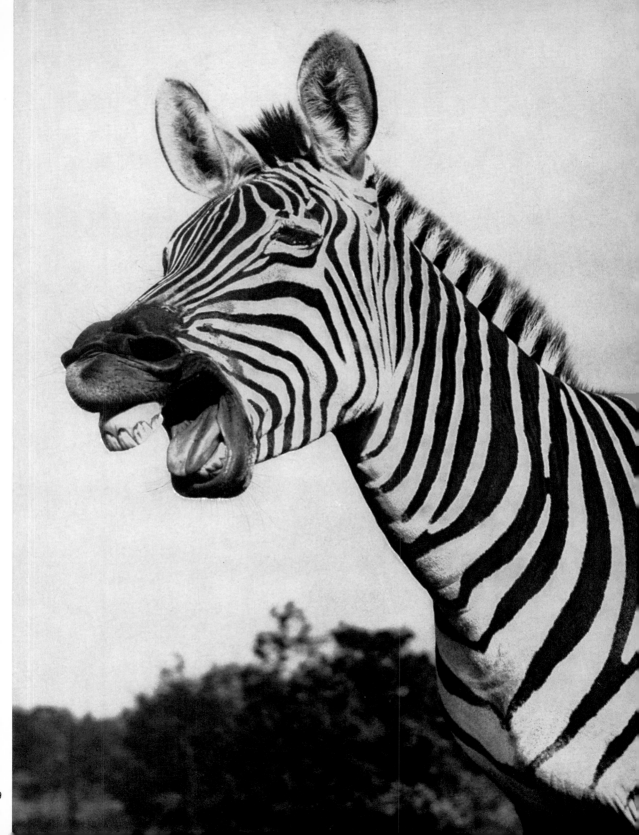

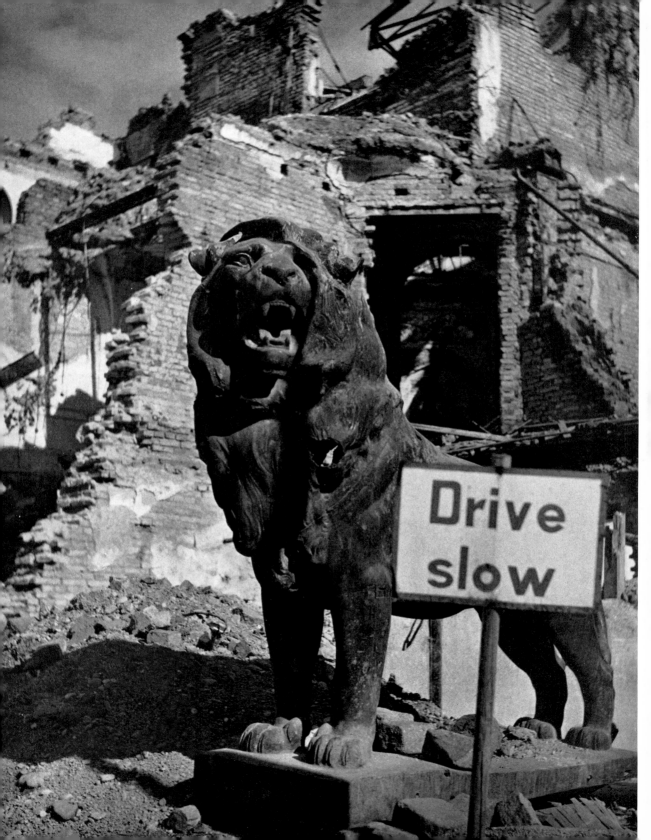

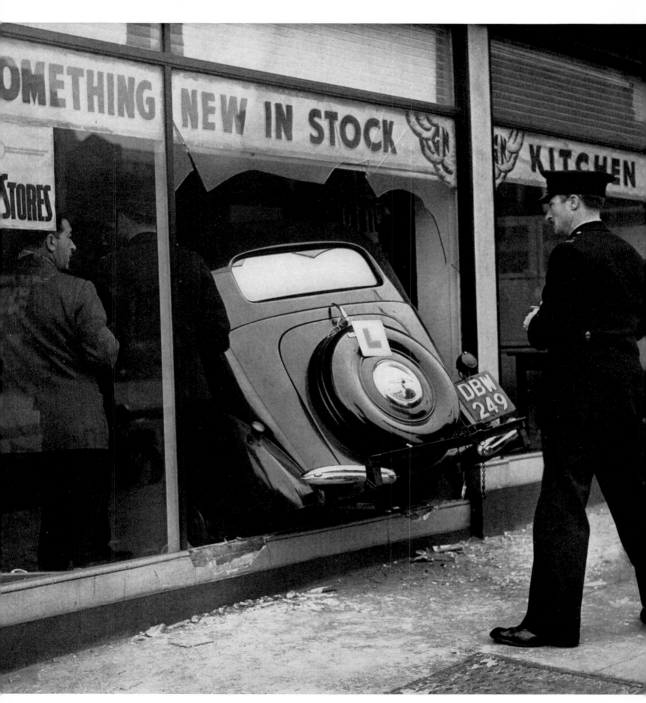

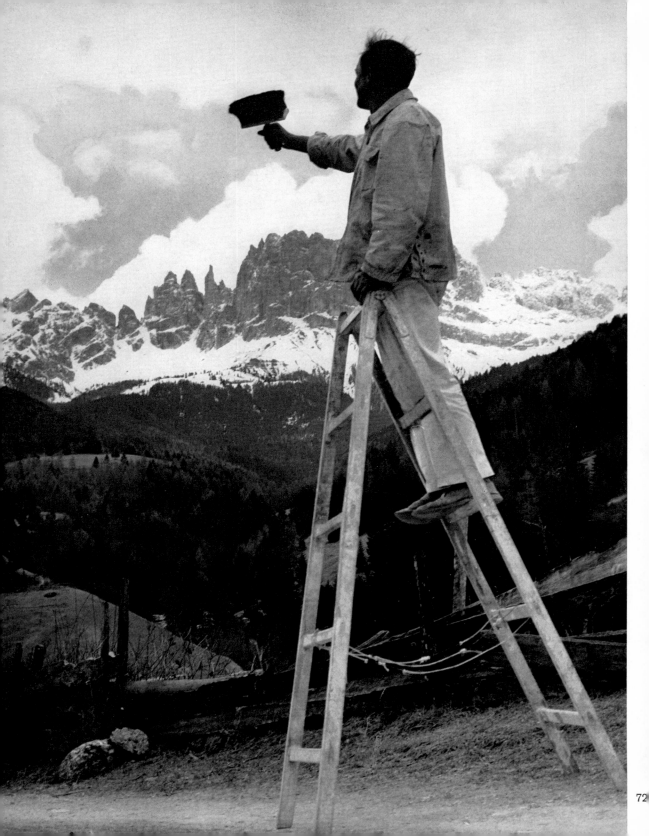

Animals of Many Lands

FLIGHT

GERMANY

IRELA

FINLAND

CHILDREN
OF
MANY
LANDS

CATS

SWEDEN

DENMARK

Chil
and T
Fat.

Laughing Camera

BERLIN